Election Stress Relieved by Coloring

This coloring book is for relaxing and escape.

As with my other books you might want to put a blank piece of paper or thin cardboard behind the design before you begin to color. This will catch any colors that bleed through.

There are many mediums you can use to color. I suggest using markers, colored pencils, gel pens, or watercolor pencils.

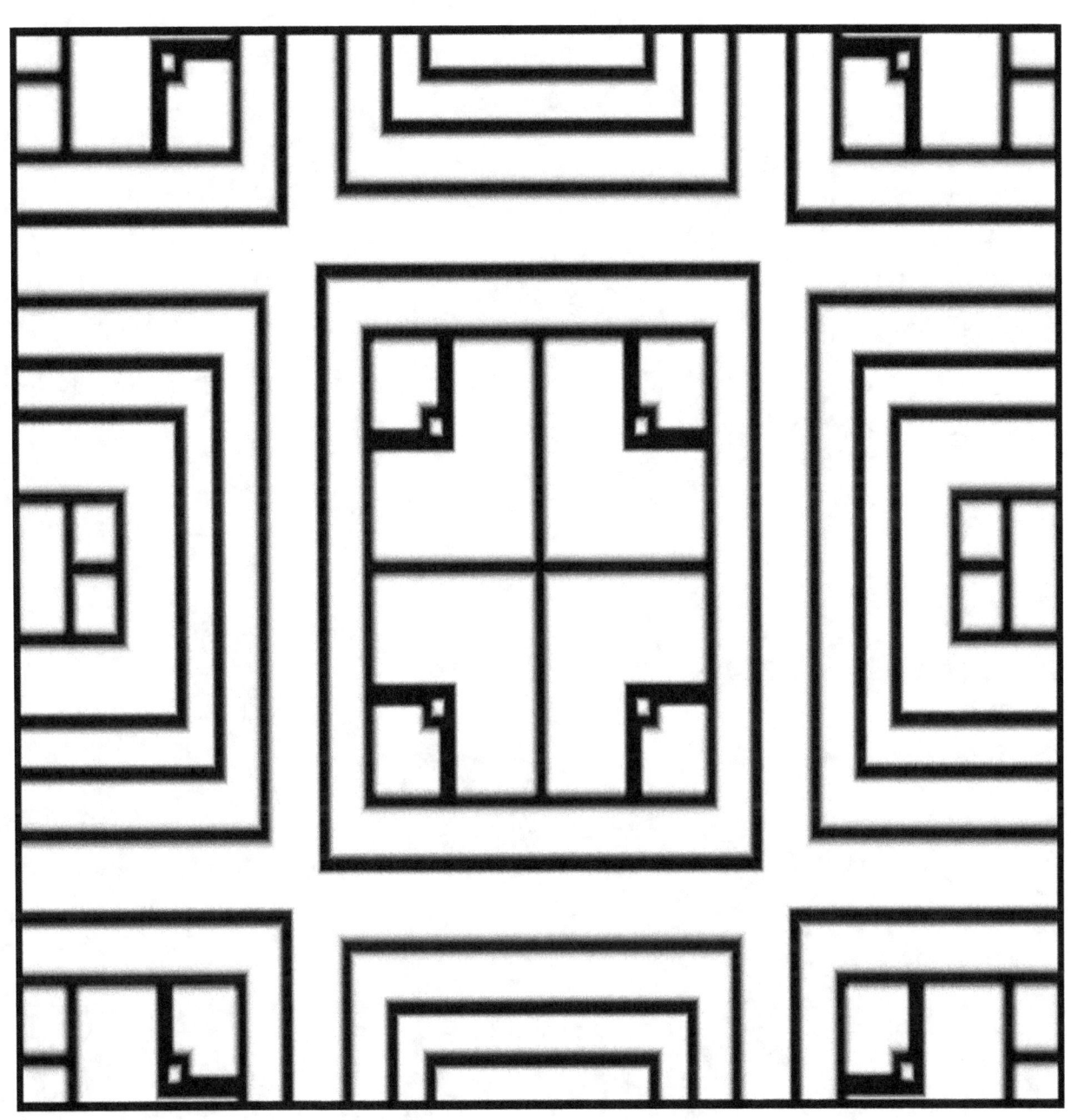

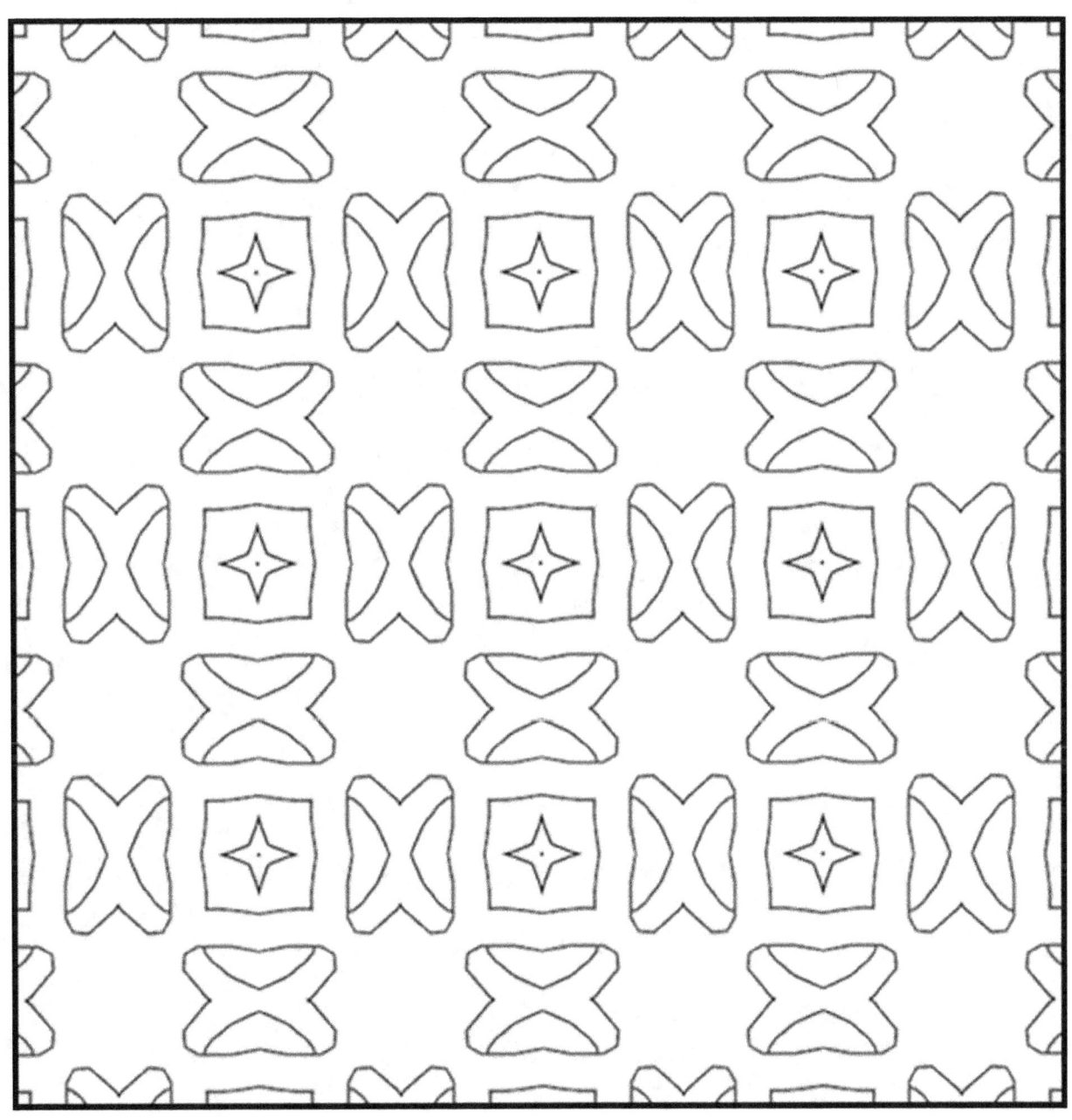

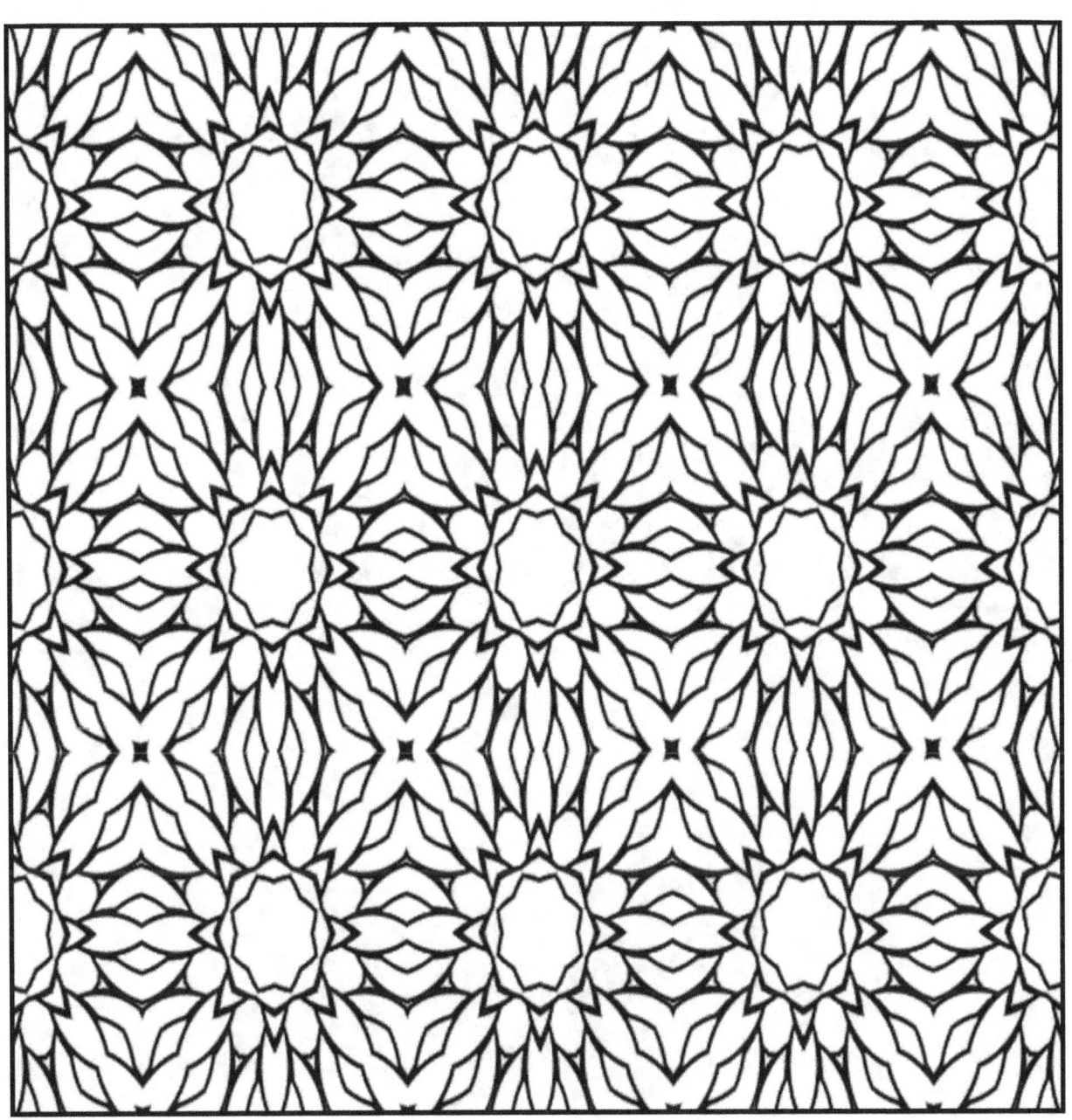

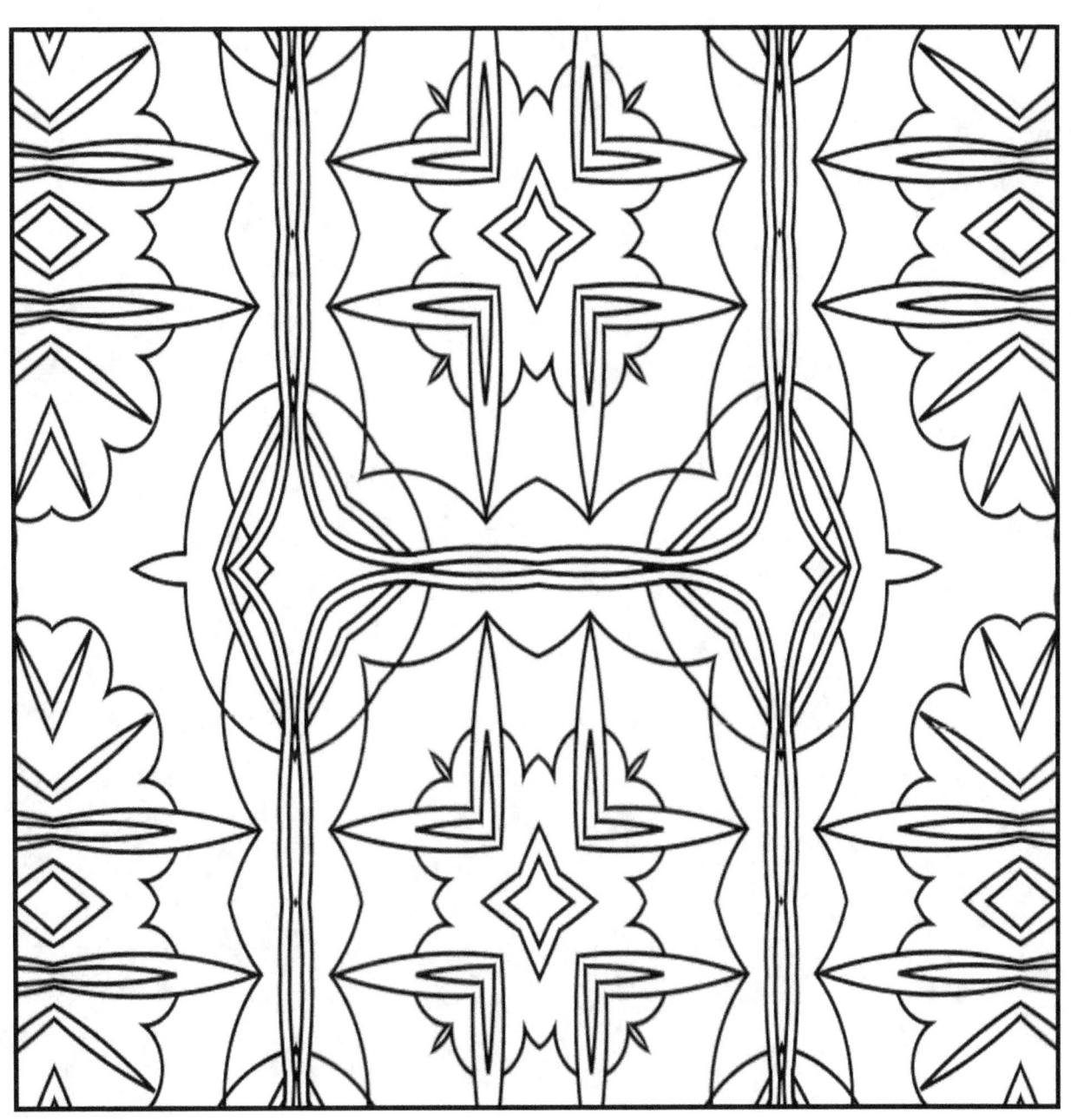

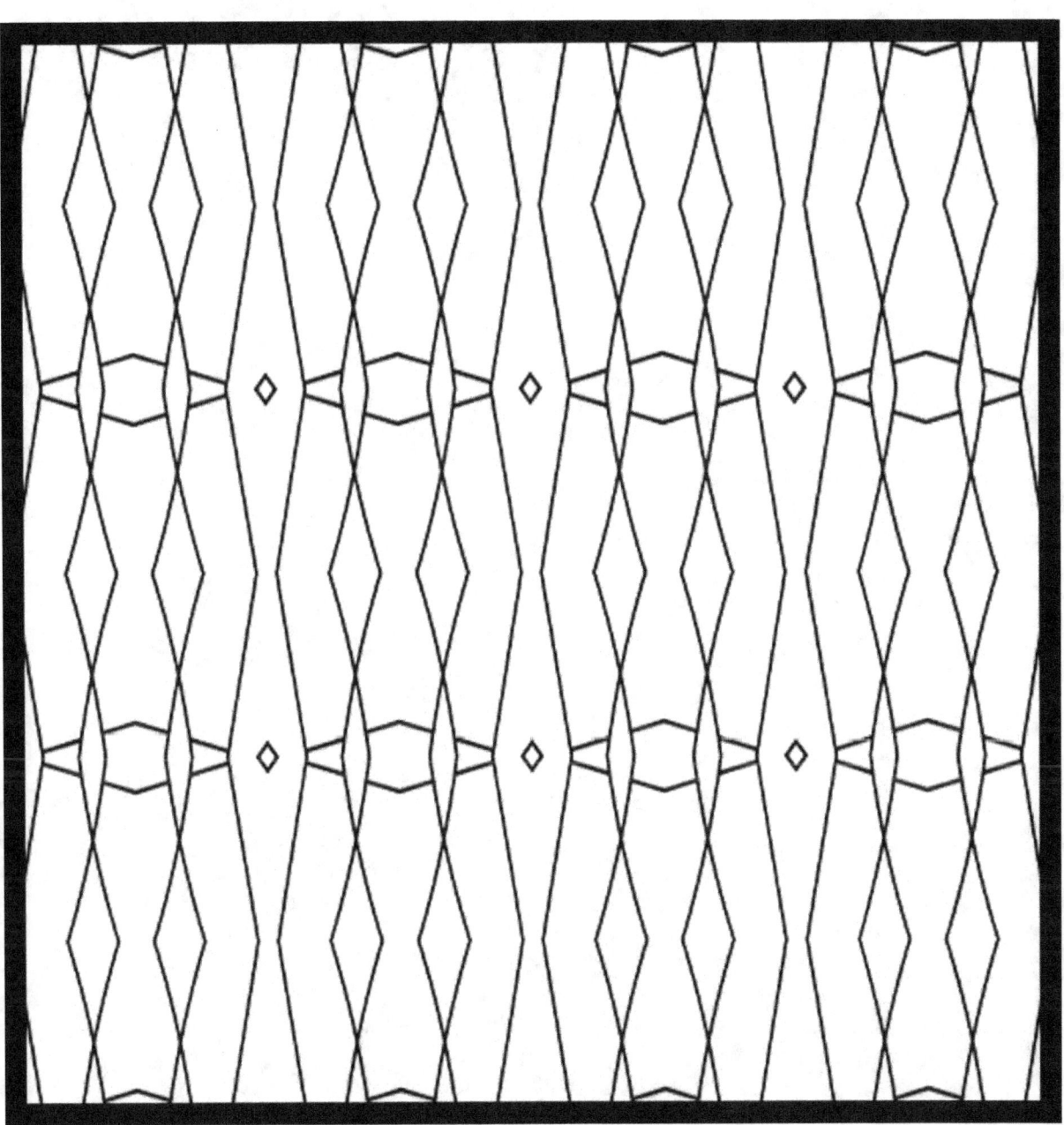

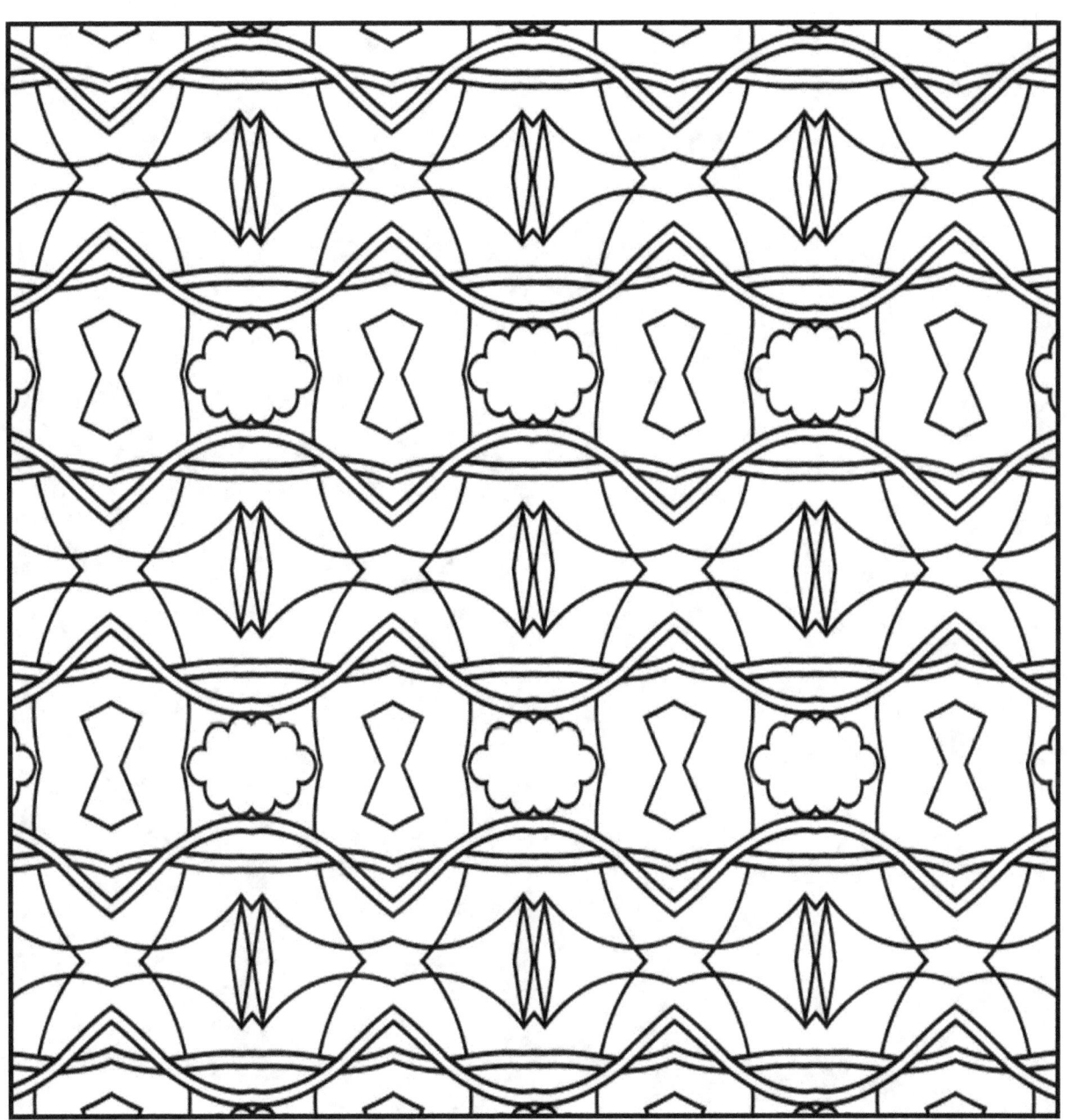

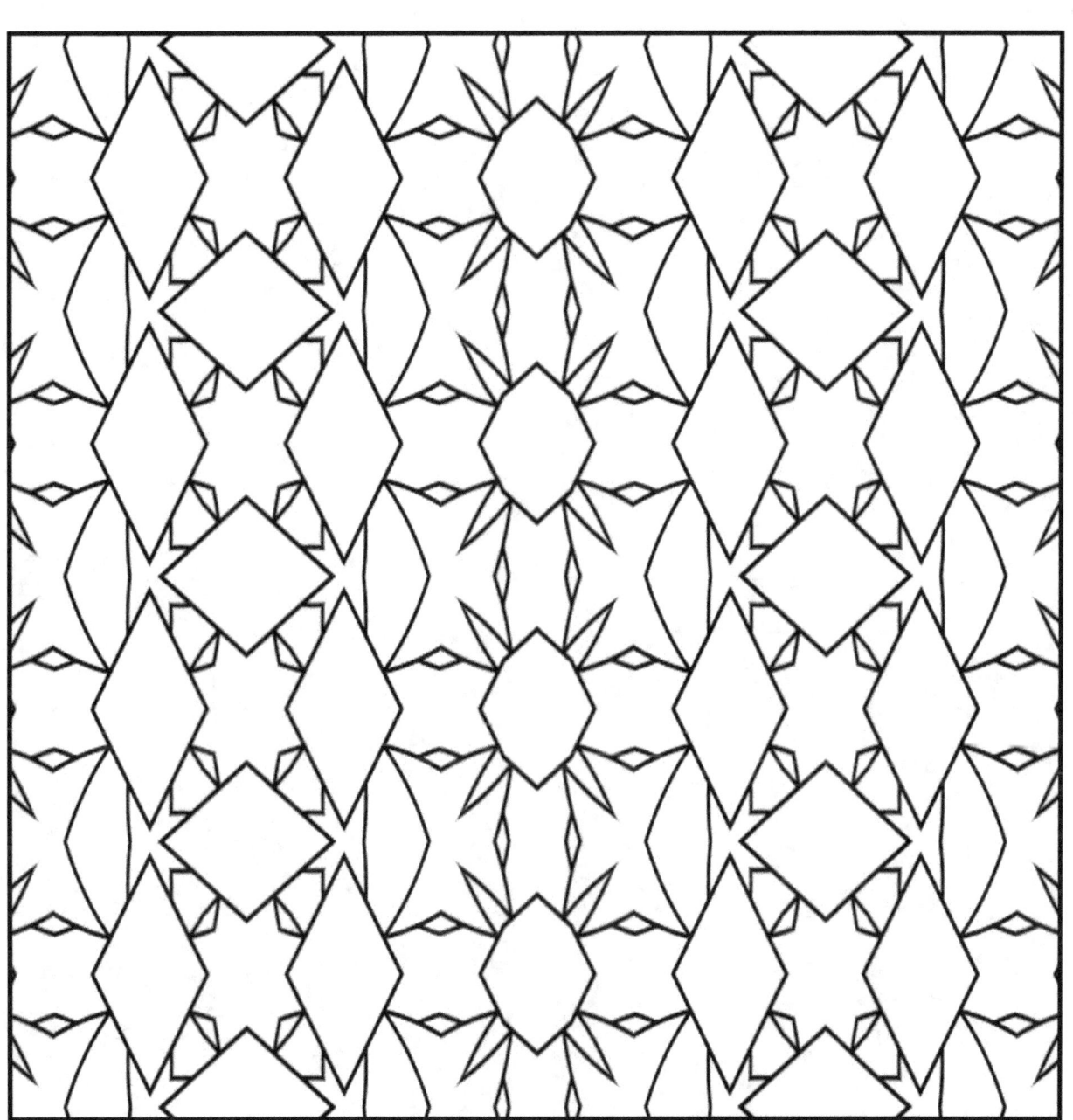

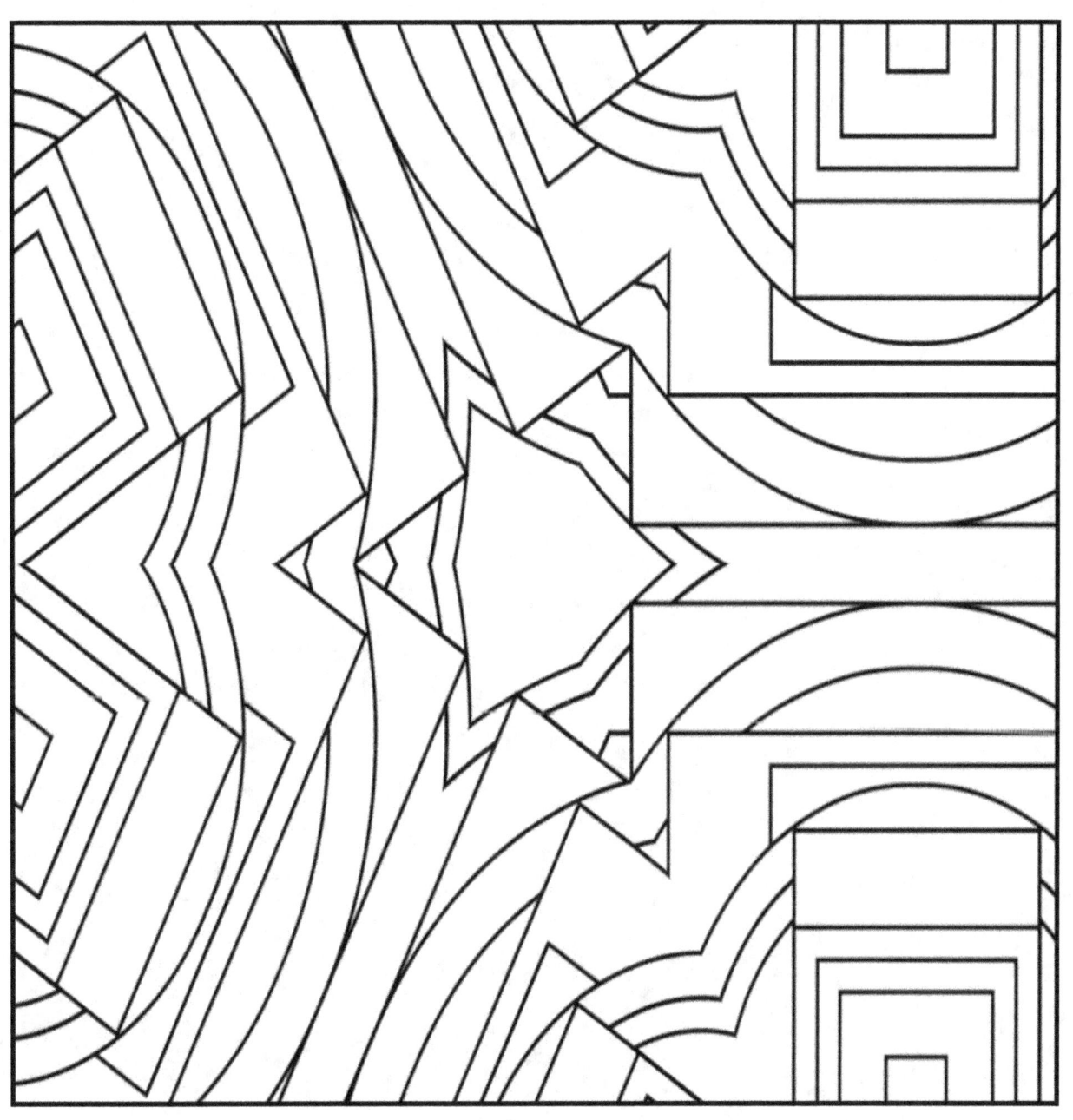

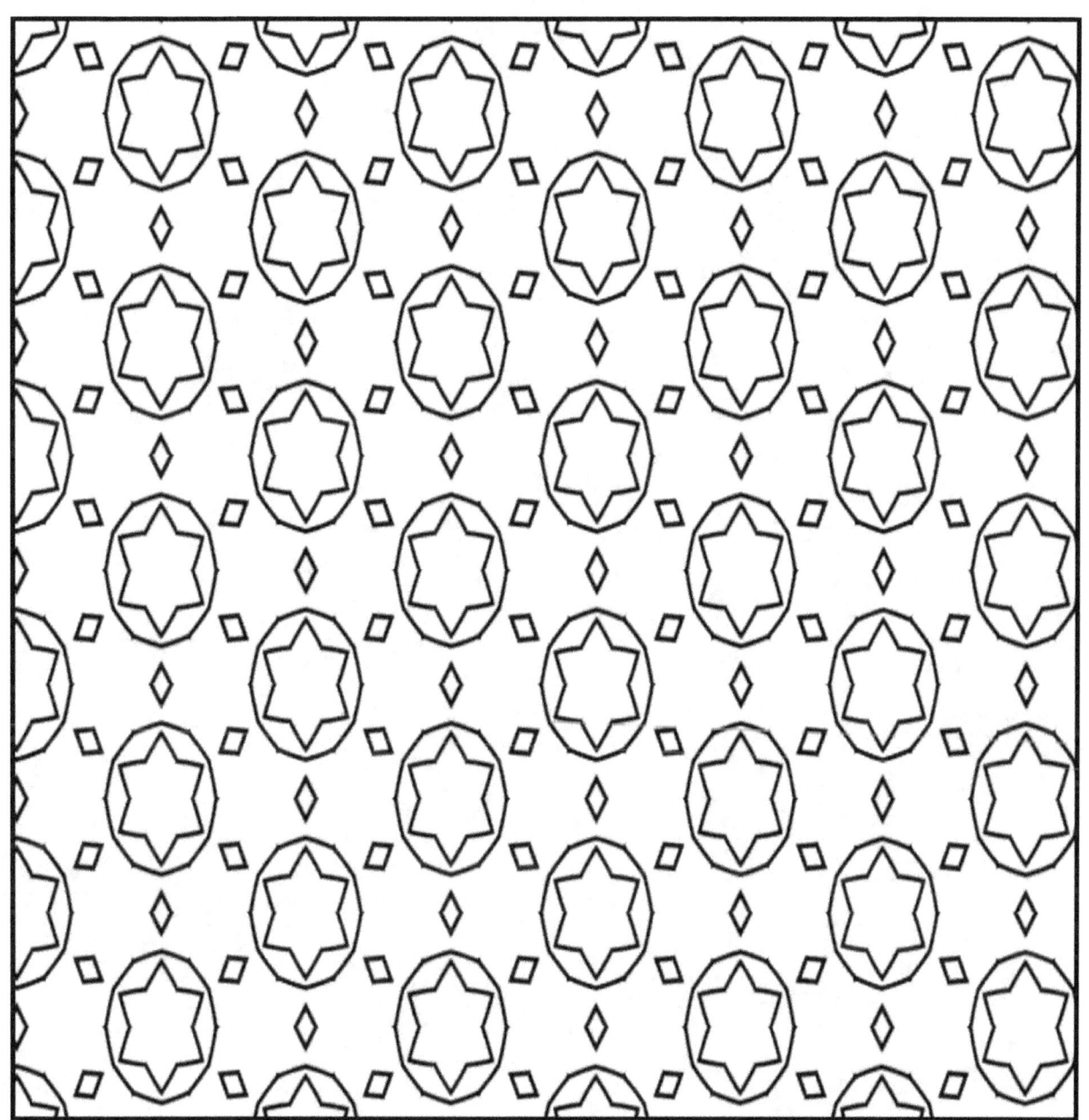

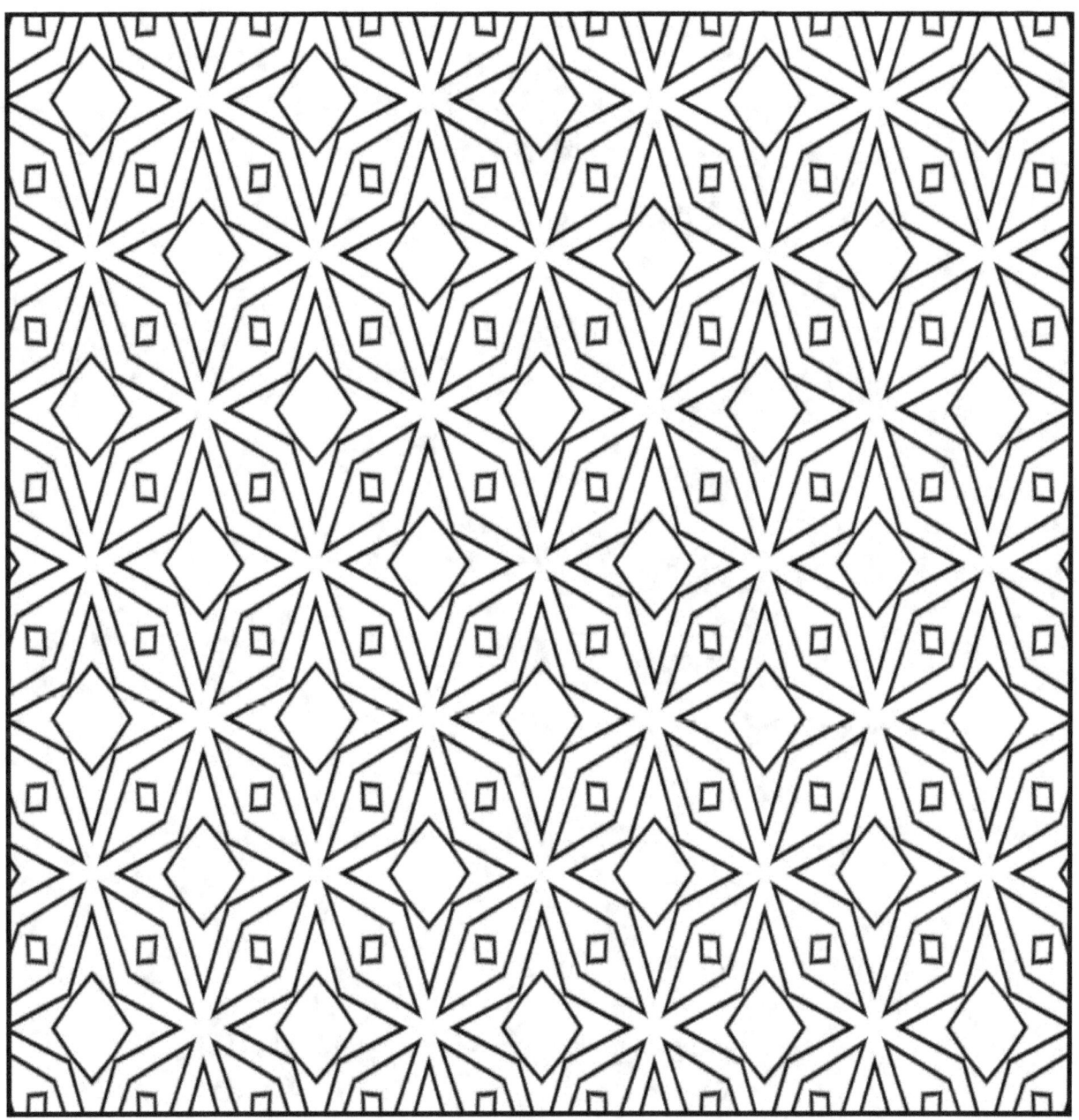

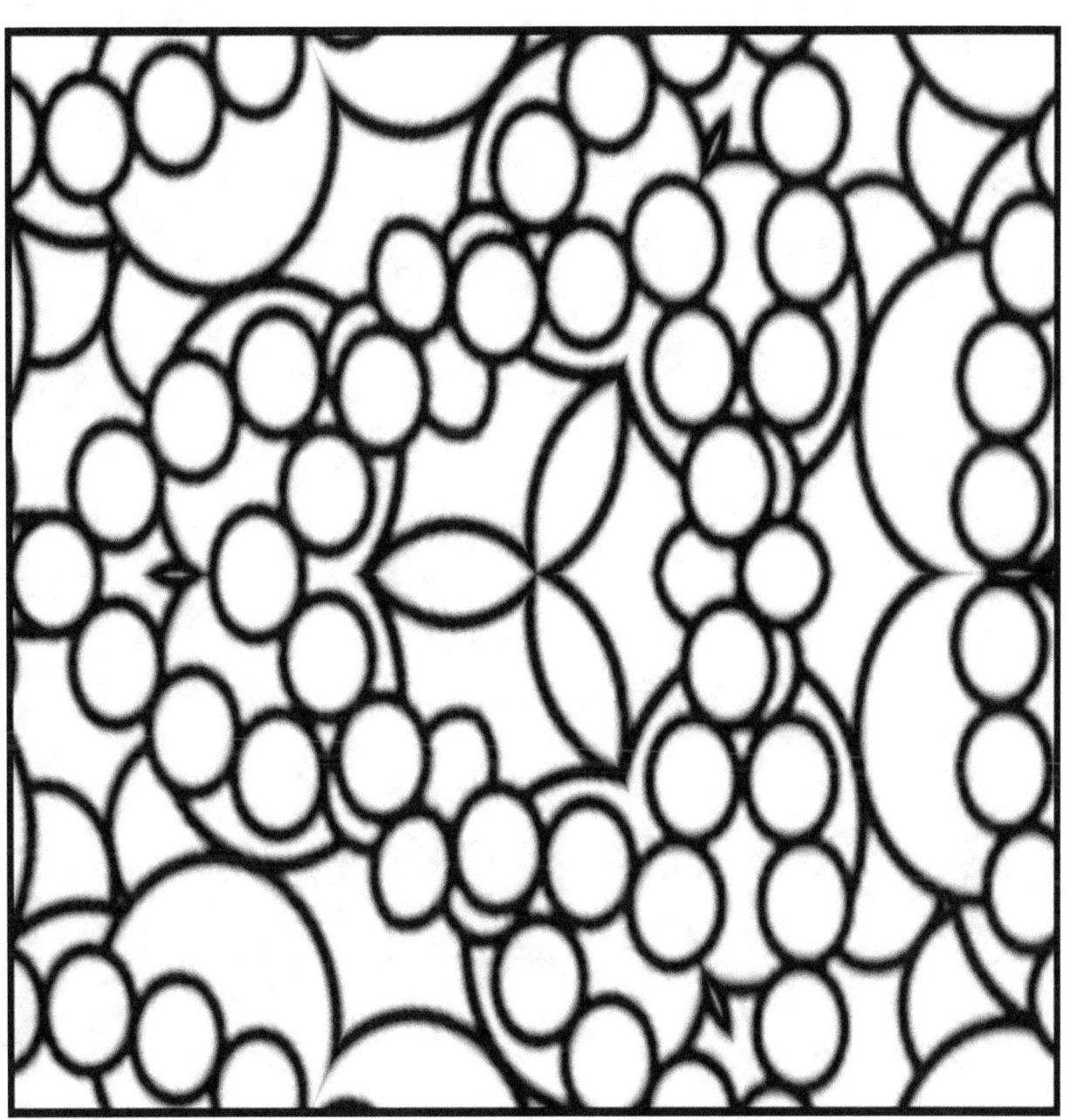

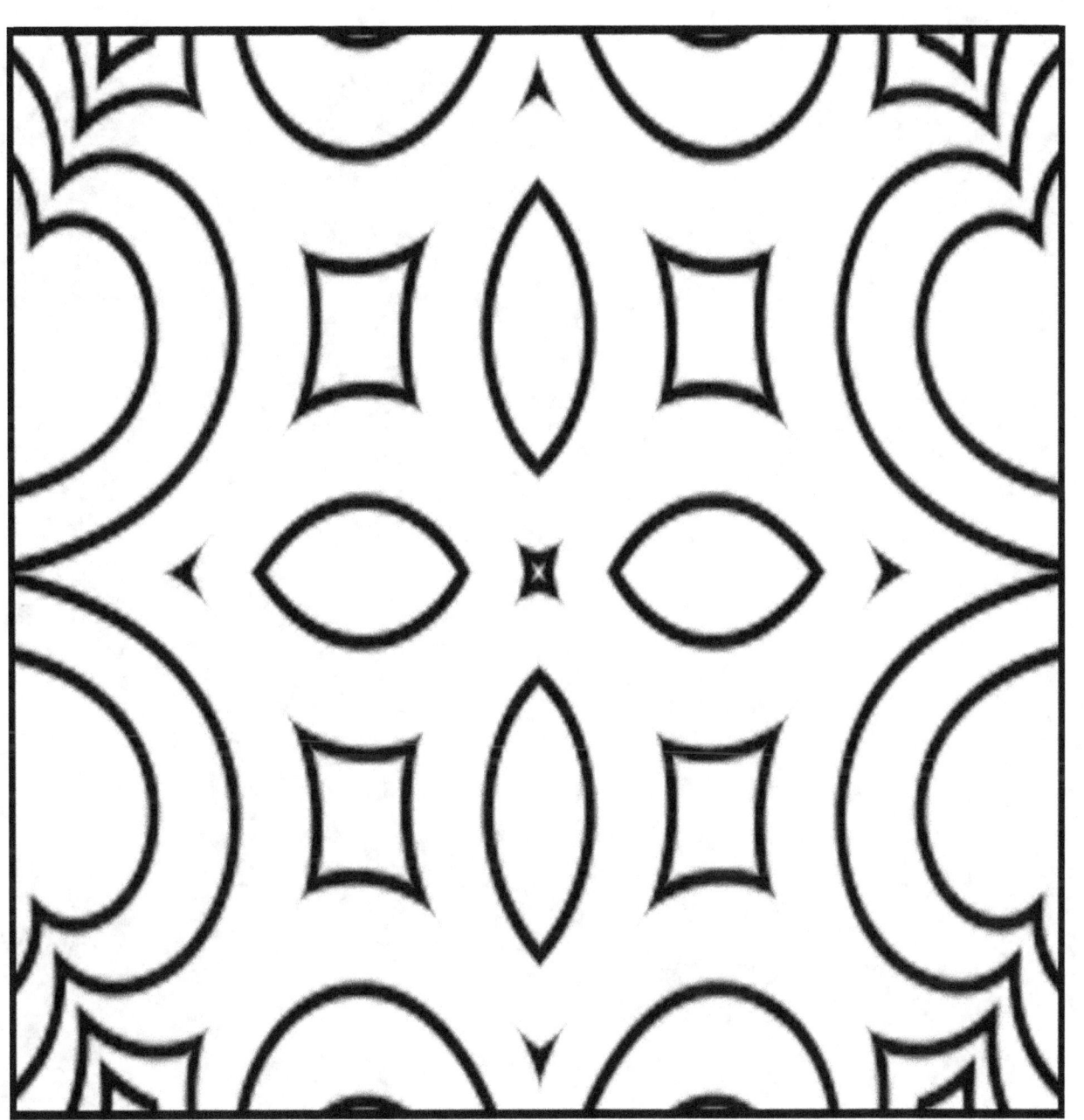

I hope you relaxed coloring these pages!

Please share your colored pages on my FaceBook page called Coloring Designs.

This is also a site for leaving questions, comments, suggestions and congratulations.

THANK YOU FOR PURCHASING THIS BOOK!

You can find my other books on Amazon.com by typing RUTH MASON in the search box.

I can always be contacted at favoritesofruthies@gmail.com

I look forward to hearing from you!

www.ingramcontent.com/pod-product-compliance
Lightning Source LLC
Chambersburg PA
CBHW081255180526
45170CB00007B/2429